D0049637

This book belongs to

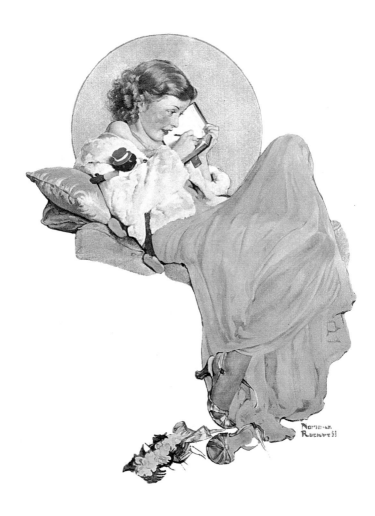

Romance

NORMAN ROCKWELL

ARIEL BOOKS

ANDREWS AND McMEEL

KANSAS CITY

ISBN: 0–8362–4709–4

Frontispiece: THE DIARY
Saturday Evening Post cover, June 17, 1933

Book design by Susan Hood

Romance

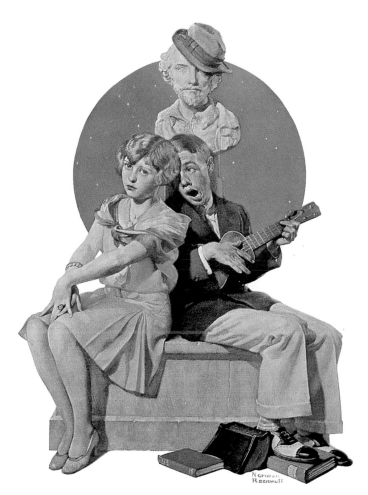

SERENADE

Saturday Evening Post cover
September 22, 1928

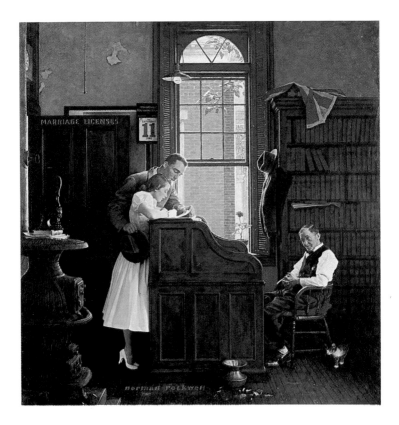

MARRIAGE LICENSE

Saturday Evening Post cover
June 11, 1955

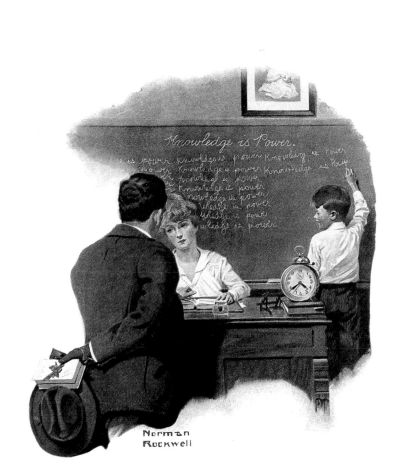

KNOWLEDGE IS POWER

Saturday Evening Post cover
October 27, 1917

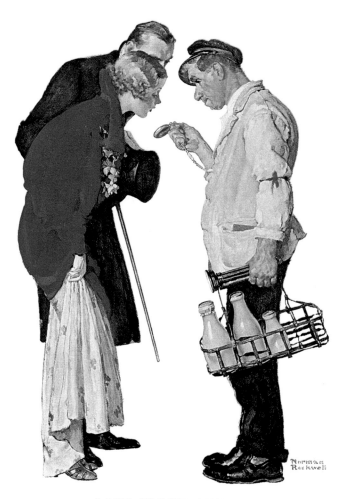

LATE NIGHT OUT

—

Saturday Evening Post cover
March 9, 1935

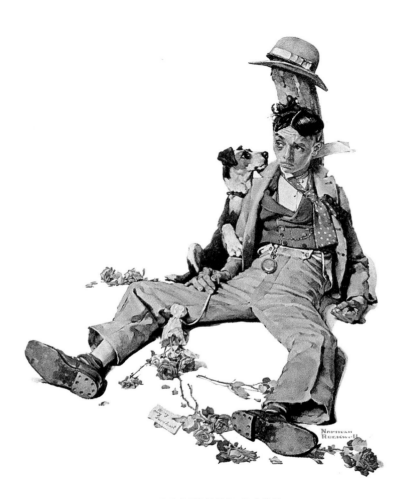

UNREQUITED LOVE

Saturday Evening Post cover
October 2, 1926

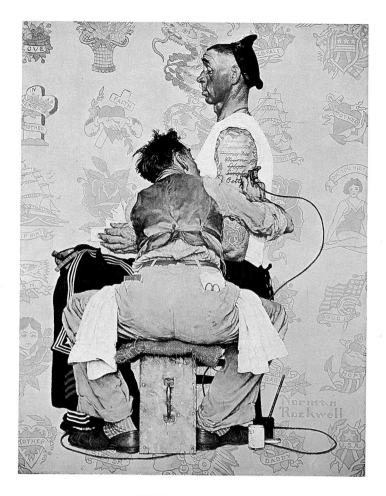

THE TATOOIST

—

Saturday Evening Post cover
March 4, 1944

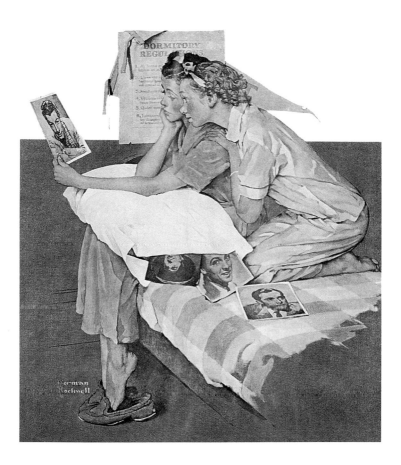

DREAMBOATS

Saturday Evening Post cover
February 19, 1938

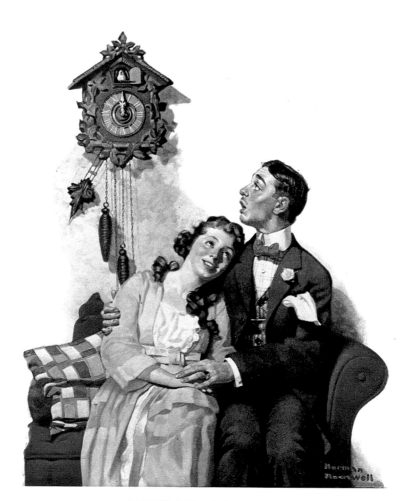

MIDNIGHT ROMANCE

Saturday Evening Post cover
March 22, 1919

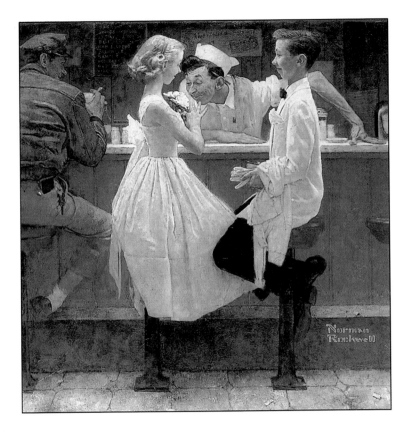

THE CORSAGE

———

Saturday Evening Post cover
May 25, 1957

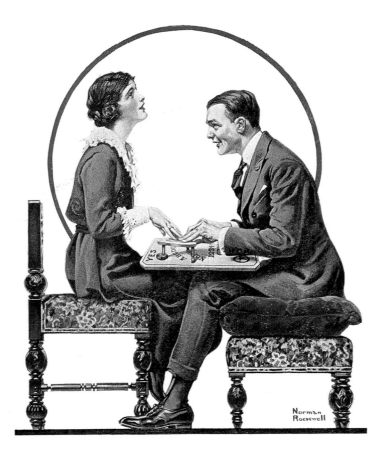

THE OUIJA BOARD

Saturday Evening Post cover
May 1, 1920

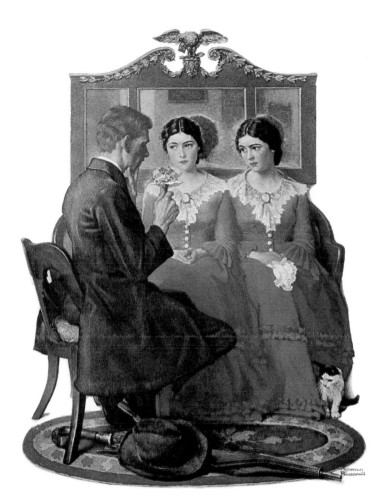

CHOOSE ME

Saturday Evening Post cover
May 4, 1929

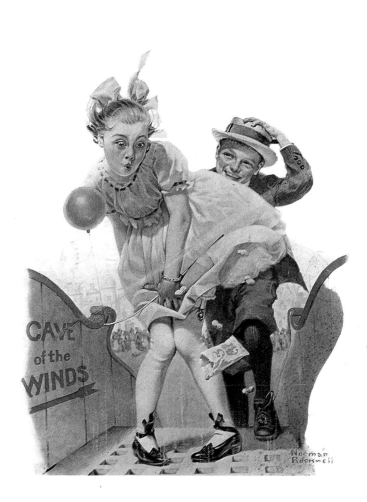

CAVE OF THE WINDS

Saturday Evening Post cover
August 28, 1920

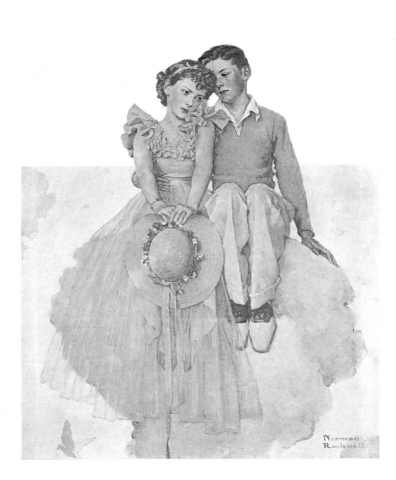

YOUNG LOVE

———

Saturday Evening Post cover
July 11, 1936

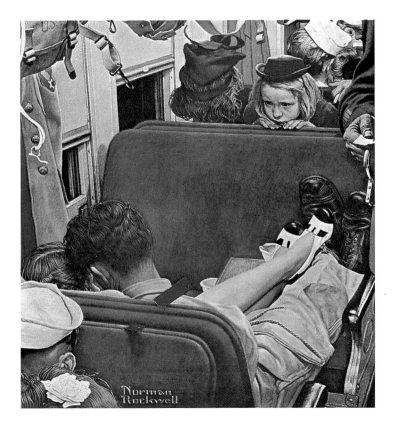

LOOKING AT LOVE

Saturday Evening Post cover
August 12, 1944

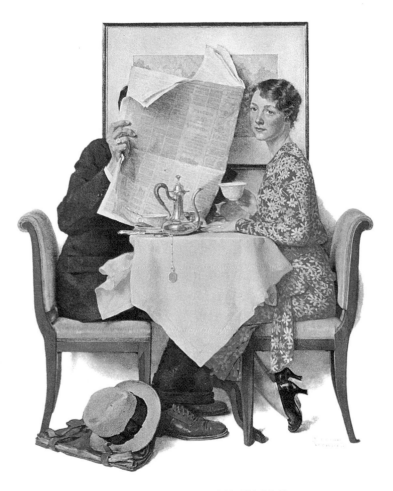

THE BREAKFAST TABLE

Saturday Evening Post cover
August 23, 1930

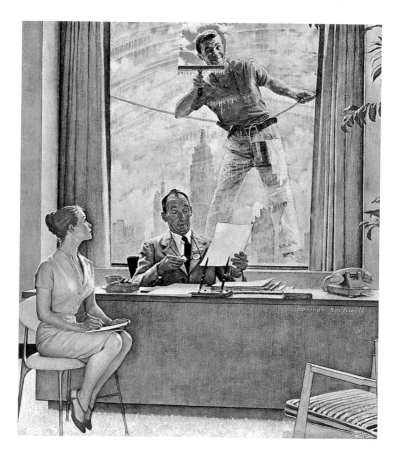

THE WINDOW WASHER

Saturday Evening Post cover
September 17, 1960

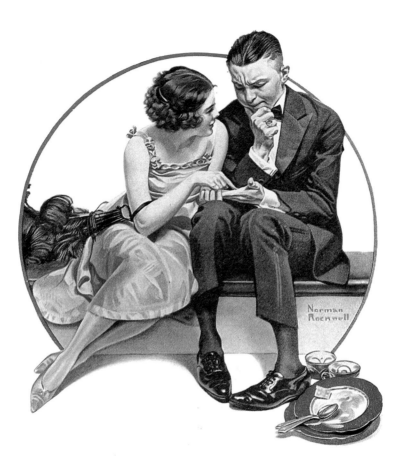

THE PALM READER

Saturday Evening Post cover
March 12, 1921

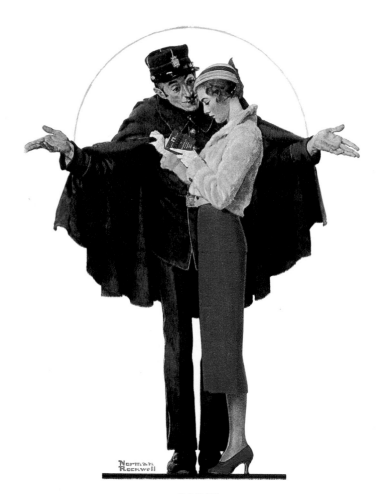

PARIS

Saturday Evening Post cover
January 30, 1932

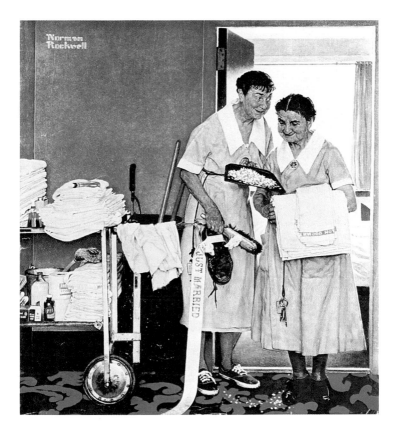

BRIDAL SUITE

Saturday Evening Post cover
June 29, 1957

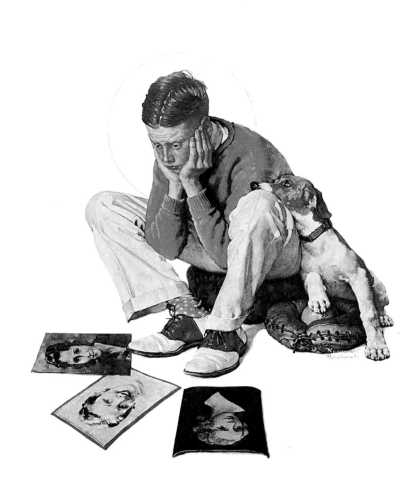

STARSTRUCK

—

Saturday Evening Post cover
September 22, 1934

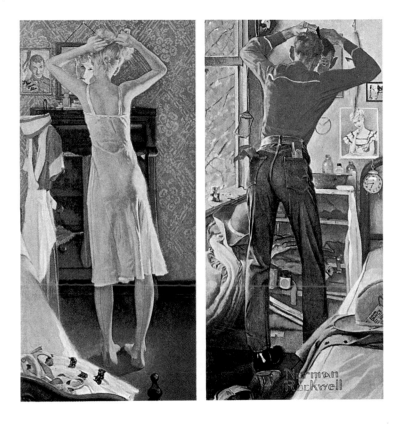

GETTING READY

Saturday Evening Post cover
September 24, 1949

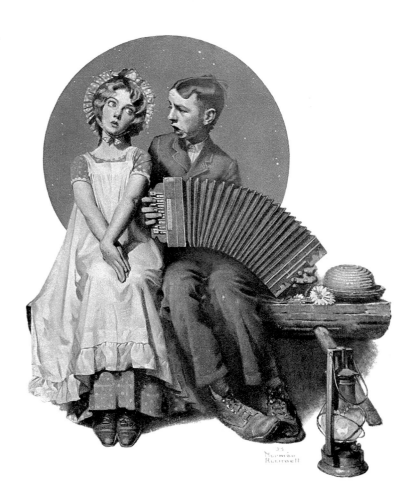

ACCORDION PLAYER

———

Saturday Evening Post cover
August 30, 1924

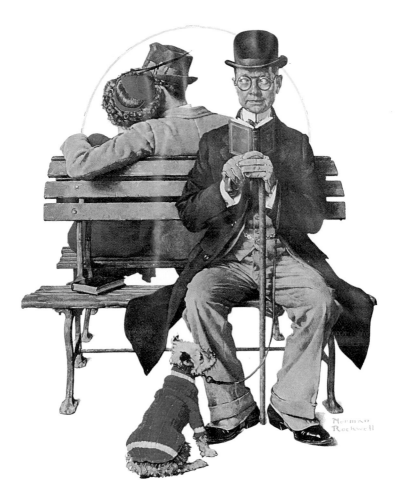

PARK BENCH

Saturday Evening Post cover
November 21, 1936

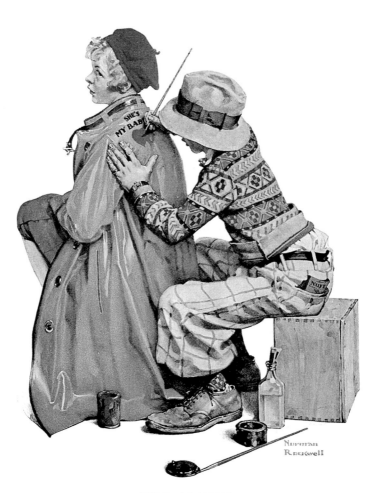

THE ARTIST

Saturday Evening Post cover
June 4, 1927

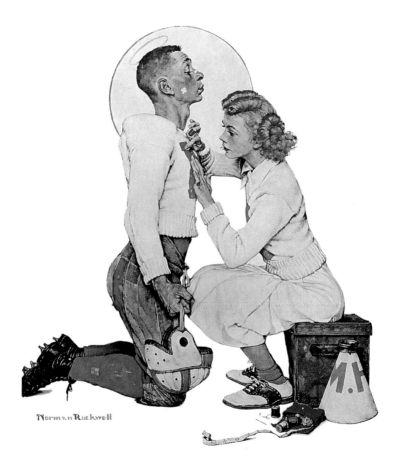

LETTERMAN

—

Saturday Evening Post cover
November 19, 1938

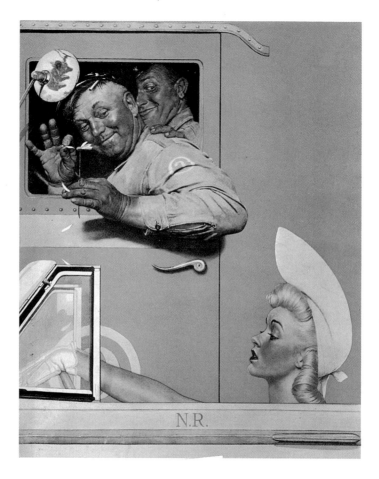

LOVES ME...

Saturday Evening Post cover
July 26, 1941

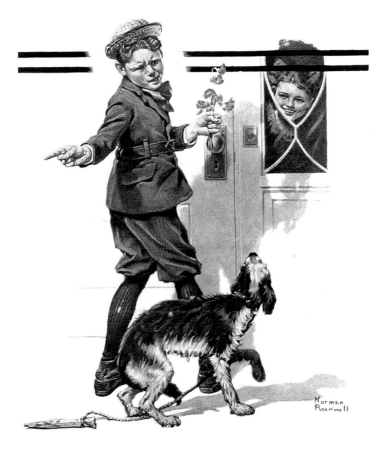

GO HOME!

—

Saturday Evening Post cover
June 19, 1920

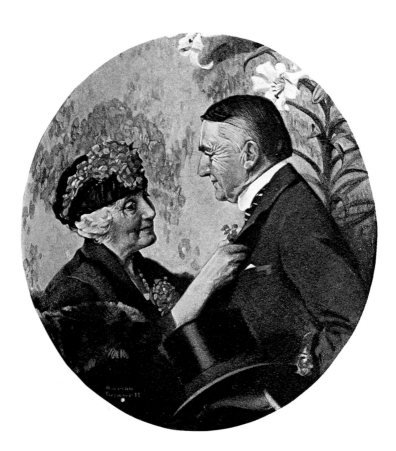

THE OLD COUPLE

Literary Digest cover
April 15, 1922

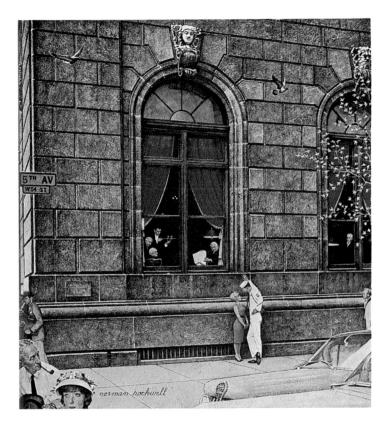

UNIVERSITY CLUB

———

Saturday Evening Post cover
August 27, 1960

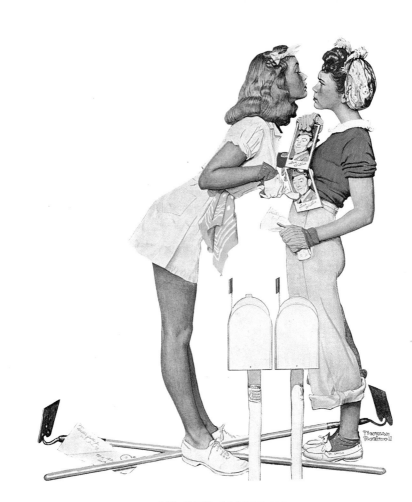

AT THE MAILBOX

Saturday Evening Post cover
September 5, 1942

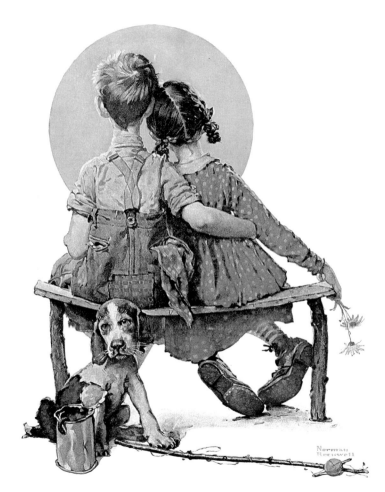

SUNSET

Saturday Evening Post cover
April 24, 1926

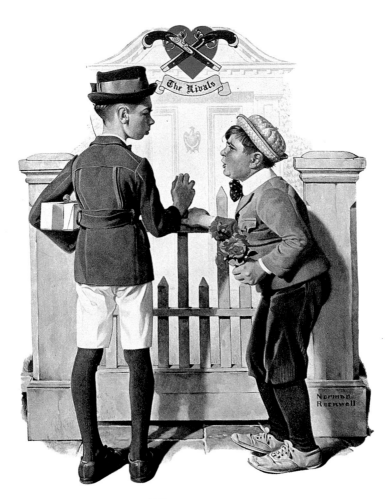

THE RIVALS

—

Saturday Evening Post cover
September 9, 1922

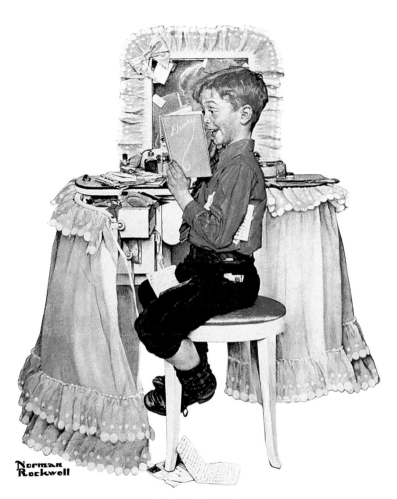

PRIVATE LIFE

Saturday Evening Post cover
March 21, 1942